FAIRY TALES

hardie grant books
MELBOURNE · LONDON

CONTENTS

THE LITTLE
DRAGON
BUTTERFLY

nce upon a time, in a clearing in the forest, a green caterpillar sat on a leaf. Two birds were watching closely from a nearby tree. The caterpillar was about to transform into a butterfly and the birds were curious to see exactly what would happen. Though they had nothing else to do anyway, it must be said that the birds had been very patient – the weather was ghastly and the rain was pouring down. Dark clouds hung in the sky and thunder rolled in the distance. With every clap of thunder, the caterpillar's leaf trembled just a little.

'I hope it starts soon,' said one bird to the other. 'I'm getting chilly.'

And indeed, before long, the caterpillar slowly started to make a cocoon around itself. Finally, where there had just been a caterpillar, a white chrysalis lay on the leaf instead.

'Oh, wasn't that beautiful!' the first bird said. 'What a magnificent spectacle! It's such a shame for the poor caterpillar that the weather's so dreadful. It must be really damp inside that cocoon.'

The clouds were very dark now and it was raining so heavily that the birds had to go in search of a bigger tree that would give them better shelter. No sooner had they settled down again to watch the cocoon than a flash of lightning zapped it with an almighty bang! The birds gasped as the cocoon flared up in a burst of red and then fizzled out.

'Oh, how awful,' said the first bird. 'That poor caterpillar must have been burnt to a crisp. Now it won't ever become a butterfly.'

'Shall we go and take a closer look?' asked the other bird. 'Maybe we can do something to help.'

When they flew over to the leaf, they saw how badly damaged the little cocoon was. But above the noise of the thunder and rain they could hear a faint little voice calling from inside the cocoon.

'Help, help!' squeaked the voice.

The birds asked what they could do to help the little creature and the voice said, 'It's boiling hot in here and I can't get out.'

The birds looked at each other, nodded, and quickly set to work with their beaks, pecking away to remove the cocoon. They expected an injured caterpillar to appear, but instead, what emerged was a small, very peculiar-looking butterfly. Its wings had jagged edges and were red with bright-green markings.

'What a monstrous little creature,' whispered one of the birds. 'It almost looks like a tiny little dragon.'

'Such an ugly butterfly!' the other bird agreed.

But even though the butterfly looked very odd, he was obviously delighted to see the two birds.

'Hello!' cried the small butterfly in his squeaky little voice. 'Thank you so much for rescuing me! I'm very grateful.' The butterfly took a good look around and then

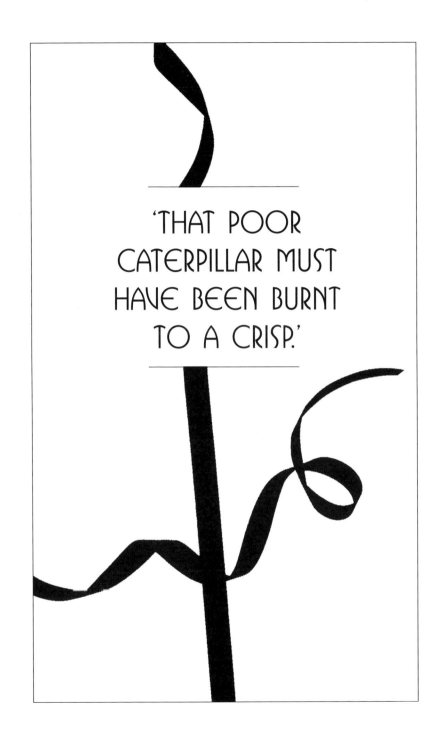

'THAT POOR
CATERPILLAR MUST
HAVE BEEN BURNT
TO A CRISP.'

'OH, DOESN'T
THIS ALL
LOOK SUPER
FABULOUS!'

said, 'Oh, doesn't this all look super fabulous!'

'You just wait until the sun comes out again,' one of the birds said to the butterfly. 'Then the world will be even more beautiful.'

'Oh, my goodness, I simply can't wait. Where are the two of you off to now?' the butterfly asked the birds.

'We're going to the Land of the Humans,' the birds replied.

'Can I come with you?' the butterfly asked.

The birds felt a bit sorry for the ugly creature they'd rescued, so they agreed to let him go with them. 'Hop up onto my back, little butterfly,' said the first bird. 'You're probably not very good at flying yet and it's a long way.'

The butterfly was even happier now as he jumped and fluttered onto the bird's back. But then he started to feel warmer and warmer, and hotter and hotter until suddenly ... the little butterfly started breathing fire! Great big flames came shooting out of his mouth. The bird squealed out in pain.

'Ow! Ow! Get off me, you nasty little butterfly!' the bird shouted.

The butterfly looked down and saw that all the feathers on the bird's back were singed and black.

'Oh, how terrible. Sorry, sorry, dear bird. I couldn't help it. I don't know what happened. I'm so sorry!' squeaked the butterfly. With a very guilty look on his face, he hopped down from the bird's back. The two birds were so angry that they just flew away and left the butterfly behind.

'You're no normal butterfly,' one of the birds yelled as they flew off. 'You're a little monster! Do you know what you are? You're a ... you're a dragon butterfly!'

The butterfly called after them, 'Don't leave me here on my own! Honestly, I couldn't help it. I didn't mean

to do it!' But as he spoke, a couple of little flames came shooting out of his mouth. He sobbed and he smouldered, but the little butterfly had to stay behind, abandoned by the two birds. As he cried himself to sleep, he wondered what was wrong with him.

The next morning, when the butterfly woke up, the sun was shining. Everything was so beautiful that he simply couldn't believe his eyes. He forgot all about how sad he had been and happily fluttered up and down. As he flew around, he spotted a bees' nest. The bees looked so busy! The place was buzzing with activity.

'Hello there, bees. You're so hard at work. What are you up to?' asked the dragon butterfly.

Over a hundred bees answered, all at once, 'Bzzz. We're making honey for our queen. Bzzz.'

'Honey? What's that? Is it nice?' asked the butterfly. One of the bees gave the dragon butterfly a little honey to taste.

'Mmmm, how delicious!' he gasped, licking up the drops of sticky goodness. 'How delightful! Thank you so much for allowing me a taste. Is there anything I can do for you? I'd love to return the kindness.' The dragon butterfly had barely finished speaking before the huge flames came shooting out of his mouth again. In just a few seconds, the bees' nest was on fire and the terrified bees were flying out as fast as their wings could carry them.

'You call that returning the kindness?' the bees buzzed angrily. 'Bzzz. Are you mad? Now we're going to have to build our nest all over again!'

'Oh, I'm so sorry, dear bees. I really couldn't help it! And this is the second time too! But I really didn't mean to do it, really and truly!'

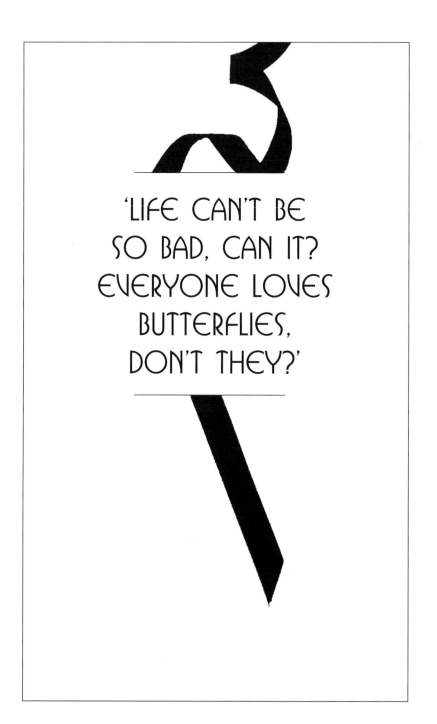

'LIFE CAN'T BE
SO BAD, CAN IT?
EVERYONE LOVES
BUTTERFLIES,
DON'T THEY?'

The bees were so angry that they charged straight at the little dragon butterfly. He took one more look at the burning nest and at the swarm of angry bees and flew away as quickly as he could.

As he escaped, he accidentally set a few trees on fire.

'Go away, you scary little freak!' the bees called after him. 'And don't ever come back!' The dragon butterfly was now in a real panic. He had no idea what was happening to him. He wondered how it was even possible for flames to shoot out of his mouth. Not knowing what else to do, he decided to go and sit beside a pond in a clearing in the forest where he couldn't set anything on fire.

'Oh, oh, oh, what on earth shall I do?' the dragon butterfly whispered to himself. 'Maybe I should head to the Land of the Humans. Who knows? Perhaps everyone there breathes fire. I can't be the only one, can I?' He felt utterly alone.

An owl heard the dragon butterfly whispering and felt very sorry for him. From high up in the tree, the owl hooted down, 'Chin up, little butterfly! Life can't be so bad, can it? Everyone loves butterflies, don't they?'

The butterfly looked up in surprise and saw the owl sitting there on a branch. 'Oh, hello, Mr Owl, how nice to meet you. I don't know if everyone loves butterflies, but they certainly don't love me. I destroy everything with my flames.'

'Flames? What do you mean?' the owl asked.

'Well, I don't know why,' replied the butterfly, 'but erm ... sometimes flames come out of my mouth.'

The owl looked very doubtful. He flew down to the butterfly and sat beside him. 'I don't believe a word of it,' the owl said sternly. 'That's impossible. Only the sun and dragons breathe fire. The sun's too far away and I've

never, ever seen a dragon. Although some people say that dragons have been spotted in the Land of the Humans ...'

The butterfly was really very worried now and said, 'Please take care, Mr Owl. It's all true, every word. I'll end up hurting you by accident too and you'll be angry with me, just like everyone else.'

The owl hooted a loud laugh and challenged the dragon butterfly to breathe fire. So the little creature turned around, took a deep breath and blew all the air out from the very bottom of his lungs. But nothing happened. And no matter how hard the butterfly tried, over and over again, all he got was a sore throat. Puzzled, he looked up at the owl.

The owl chuckled. 'If you ask me, you're just after a bit of attention. You can't breathe fire at all!'

The butterfly was very confused. He was about to say sorry to the owl when he suddenly felt that burning sensation inside, and before he could warn him, big flames started shooting out of his mouth again. Within just a couple of seconds, the owl's entire head was on fire.

'Ow, ow!' the owl screeched, diving into the pond to put out the fire. When it was extinguished, the owl climbed back out of the water. The butterfly didn't dare look at the damage he'd done. He covered his eyes with his wings.

'Sorry, Mr Owl. I tried to warn you, but it all happened so quickly.'

The owl was upset, but he knew that it wouldn't have happened if he'd believed the butterfly. He looked at his reflection in the surface of the pond and was startled to see the bald and blackened face looking back at him. He only had feathers on his body now!

'Just go away, you peculiar little creature, before I get really angry. Take yourself off to the Land of the Humans,

'SORRY, MR
OWL. I TRIED
TO WARN
YOU BUT IT
HAPPENED SO
QUICKLY.'

like you were planning to do. Those humans are very good at destroying things too, so I'm sure you'll feel right at home.'

The dragon butterfly flew away as fast as his jagged wings could carry him.

'I'm so tired,' sighed the dragon butterfly. 'Ever since I came out of my cocoon, I've been running away. I'd love to have a place I could call home. Those poor birds, the poor bees, that poor owl. They must really hate me.'

The dragon butterfly flew all night long until, exhausted, he reached the Land of the Humans. The first thing he saw were big factories spewing flames and clouds of smoke. Even though he was so tired from flying, he still felt happy to see other fire-breathing creatures and he headed straight for them. These must be the humans that everyone had told him about!

'Hello, humans!' the dragon butterfly called. 'It's so nice to meet you! I can breathe fire too!' And a big flame came out of his mouth. But the chimneys didn't respond. Disappointed, the little butterfly settled on the side of one of the chimneys. A big black beetle trundled along and said, 'Those aren't humans, you silly butterfly. They were just made by humans. Oh, and humans don't breathe fire, by the way.'

That wasn't what the butterfly wanted to hear. He hung his head and let out a deep sigh.

'Oh, Beetle, I'm so tired and I've travelled so far. I damage everything I see, even though I always have the best of intentions. And I was really hoping to find someone else who could breathe fire.'

'Only dragons breathe fire. Once a year, they fly across the country on their way to Dragon Hill. They'll be here again soon. Next week, when the moon is at its smallest, it'll be time for the dragons to fly. All the

animals in the Land of the Humans will hide and the humans will dim their lights and close their curtains. No one has ever seen a dragon close up, but they say that a dragon's flames can destroy an entire village in one single blast.'

The story scared the little butterfly, but he felt more hopeful now that he was sure there were other fire-breathing creatures. Shouldn't he follow the dragons and try to make friends with them? It would be dangerous, but he so wanted to get to know other animals of his own kind.

'I am very grateful to you, Beetle. Do you know what I'm going to do? I'm going to follow the dragons when they fly over.' The beetle shook his whole body doubtfully and warned the dragon butterfly to be very, very careful.

The dragon butterfly stayed by the factory all week, waiting for the dragons to come. He steered clear of everyone else so his flames did no more damage than a little singed grass and a few black patches on a brick wall. Every night, he looked up at the sky, full of hope, but he didn't see anything that resembled a group of dragons. He waited and waited until one night the moon was at its smallest and the sky was very, very dark. No fire had come from the chimneys for days, so you can imagine how black it was!

In the distance there came a dreadful sound. It was like thunder and lightning and hail and storm winds and explosions, all going on at once. Shaking with fear, the dragon butterfly looked up at the sky and saw a group of big black shapes flying through the air; dark, dark shadows against the dark, dark sky. The dragon butterfly thought about his short, sad life, and then plucked up all of his courage and flew towards the group of dragons. It wasn't hard to follow them because they were making so much

BUT THEN THE
DRAGON BUTTERFLY
NOTICED SOMETHING
THAT MADE HIM GASP.

noise. Oh, the little dragon butterfly was so scared! But, bravely, he went on flying, flapping his jagged wings as fast as he could, because he was much smaller than the dragons.

It was a real struggle for him, but fortunately the sun was slowly coming up, and Dragon Hill appeared on the horizon. The dragons flapped their wings and made their way to their hill, where they all perched right at the top.

The dragon butterfly landed carefully behind a big rock, some distance away from the dragons. When he peeped around the edge, he saw for the first time just how big and scary the dragons were. They had huge tails and wings and they were covered with red and green scales. They had what looked like sharp, triangular teeth running all along their spines and every one of them was breathing fire! The dragons were a terrifying sight.

But then the dragon butterfly noticed something that made him gasp. In amongst all those scary animals, he spotted a beautiful little lady dragon. Her wings were gossamer-thin, her scales seemed to be made of the silkiest fabric, and her eyelashes were very, very long. When she blinked, it almost seemed as though there was a breeze. But she wasn't breathing fire! She was the only one who was sitting there quietly with not even a puff of smoke coming from her mouth. She looked rather lost in that group of monstrous beasts. The little dragon butterfly had never seen anything so beautiful in his life! He stopped thinking about breathing flames – and fell head over heels in love.

The dragon butterfly could hear the dragons talking about the beautiful little dragon. The largest of the dragons said angrily, 'Dragons are supposed to strike fear into human hearts. Are we not terrifying creatures?' He jabbed a claw at the delicate little dragon with the long eyelashes

and said, 'She is incapable of breathing fire and is quite simply too sweet and – ugh! – too pretty to be a real dragon. Why, her wings are so thin that she looks almost like a butterfly. She's an embarrassment to dragonkind!'

A female dragon replied. 'But my daughter can't help that, can she? It's because the sun shone on her egg when she was born, even though I did my best to keep it in the shade. It's me you should be blaming, not her. I'll just have to teach her to look scary. Maybe she could shout "Boo!" instead of breathing fire!'

All the dragons were so wrapped up in the discussion about the little dragon with the long eyelashes and the thin wings that they didn't notice her quietly backing away and leaving the group. She stopped by a cluster of flowers and quietly sobbed, 'Oh, beautiful flowers, I love you so much, even though it's not really allowed, because I'm a scary dragon and I should burn you to a frazzle. But you smell so sweet.' She sighed. 'Oh, I'd really love to be able to destroy things, but I just can't.'

By now, the dragon butterfly was so in love that it felt as though his heart would beat its way right out of his chest. 'She's like me, but she's more of a dragon who's a little bit butterfly and I'm more of a butterfly who's a little bit dragon. That's it! I'm a dragon butterfly and she's a butterfly dragon.'

The dragon butterfly picked a bunch of flowers and tiptoed up to the butterfly dragon. 'These are for you, beautiful dragon,' he said. But as he handed over the flowers, he accidentally blasted them. All that was left were a few scorched stalks.

'Oh no, not again!' said the dragon butterfly. 'I destroy everything I see that's beautiful and there's nothing I can do about it. I'm so sorry. I so wanted to give you some beautiful flowers. I followed the dragons all the way

22

here from the Land of the Humans.

The dragon with the long eyelashes and the thin wings flushed pink with happiness. 'How brave of you, beautiful butterfly. Everyone's so terrified of dragons. Well, all dragons except me. I can't breathe fire, you see. People just laugh at me. I'm an embarrassment to dragonkind.'

They talked for a while and fell terribly in love. They were so absorbed that they didn't realise the other dragons had found them and were standing around them in a circle.

'What on earth is the meaning of this?' roared the largest dragon. 'A butterfly on the hallowed ground of Dragon Hill? How dare you!'

The dragon butterfly shook with fear, but he was so in love with the little dragon that he used all of his strength and all of his breath to make the biggest flame that had ever come out of his mouth. The dragons stepped back in amazement. They'd never seen a fire-breathing butterfly before.

The dragon with the long eyelashes and the thin wings was very proud of her new flame. He plucked up all of his courage and bravely announced, 'I am in love with your little dragon. I don't care that she can't breathe fire and doesn't look scary. She's the most beautiful creature I've ever seen. I don't think I can live without her.' He looked deep into her eyes and took her claws in his. 'Will you join me?' he asked her quietly.

'We don't belong anywhere, except with each other,' said the little butterfly dragon with the long eyelashes.

'I'm so happy I met you,' said the dragon butterfly. 'Come on! Let's fly all the way to the sun.'

And that's exactly what they did.

THE TWO
MOONS

YOU KNOW...

the earth is a planet, don't you? The earth spins around the sun and the moon spins around our earth. And there are lots of other suns and planets and moons out there in the universe – too many to count! Somewhere out there, far, far away from our planet, there was once a planet that was completely black. It was uninhabited, just like most planets in the universe. The planet was a very, very quiet place indeed.

Two moons circled the black planet. They both turned calmly around, each in their own orbit, and sometimes their paths crossed and they saw each other. That happened every year on exactly the same day. It was only ever a very brief encounter, because the magical forces of the universe soon pulled the two moons apart and sent each one spinning off on its own course.

In the beginning, they both thought that not seeing much of each other was perfectly pleasant. Life was nice and peaceful. They didn't have much to say to each other, after all. But thousands of years went by and the two

moons started to get a little bored. Things can feel a bit lonely when you spend 364 days of the year on your own.

When they finally saw each other again, one of the moons summoned up all of his courage and spoke to the other moon. 'Hello, Moon, we've met thousands of times, but we've never really got to know each other.'

They were both happy to be having a conversation at long last. Full of enthusiasm, the other moon replied, 'Hello, Moon. You're absolutely right. It's so nice to speak to you for the first time! Your name is Moon too, isn't it? Hmmm, that could get a little confusing.'

'Oh,' said the first moon, 'I hadn't really thought about that. You can give me a name if you like. From now on, I shall be called whatever you want to call me.'

There was a short silence and then the other moon replied, 'You can be A and I'll be B.'

Of course, as this conversation was going on, both moons had continued on their paths and they'd already gone so far that they could barely see each other.

'Okay, A,' Moon B shouted. 'See you next year!' And then the black planet blocked their view again.

'What a shame we never said hello before,' both moons thought. 'We'd be such good friends by now.' And though they had once gone spinning calmly and peacefully around the black planet, now they became restless and impatient because they were so looking forward to their next meeting.

Oh, the usual orbit around the planet really did seem to drag on that year! Moon A had a year to think about his next question for Moon B, and when he'd come up with a question, he couldn't wait to ask it.

After a very long wait, they saw each other approaching in the distance. 'Hello there!' Moon A called immediately,

'HELLO, MOON, WE'VE
MET THOUSANDS OF
TIMES, BUT WE'VE NEVER
REALLY GOT TO KNOW
EACH OTHER.'

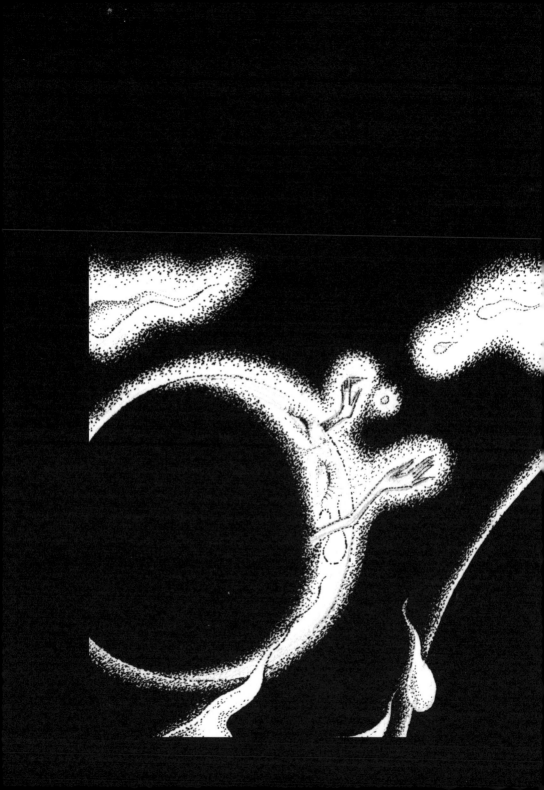

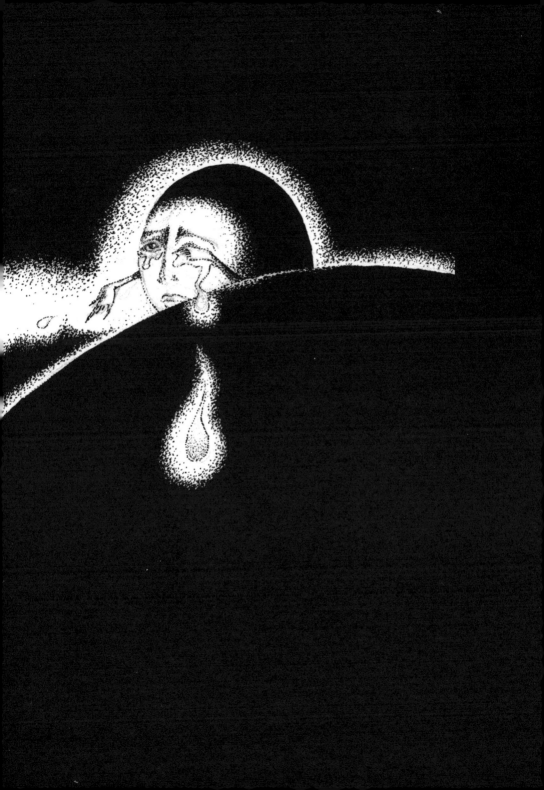

'WHAT DO I LOOK LIKE?
YOU'RE ROUND
AND GREY ALL OVER.'

so as not to waste any time. 'What do I look like? You're round and grey all over.'

'How funny!' said Moon B. 'So are you. We must look just the same! I think you're very beautiful, you know. The rest of the universe around here is so bare and empty.' Moon A was most flattered and told Moon B how boring life was when Moon B was all the way around the other side of the black planet.

'Can't we think of something that would allow us to spend more time together, so we could have more of a chat?'

It was already too late for Moon B to answer, but they had another year to think about what to say. The two moons tried with all their might to spin backwards or to spin faster, so they could meet sooner, but it didn't work. The forces of the universe are the most powerful forces out there, and the two little moons could not compete. They tried their hardest to shout to each other too, but they never got a reply.

The wait was so long that they both became a little sad. 'What's the point of spinning around all on your own? Why can't we spin together?' they wondered.

The next time they met, they told each other how loud they'd shouted and how hard they'd tried to reach the other one, but that nothing had worked.

'Why don't we each keep a diary?' Moon A said. 'Then we can swap them next time and spend all year reading about each other.'

'What a good idea,' Moon B said.

So that's what they did. Every day, the two moons wrote in their diaries about how lonely they felt, about how quiet it was without the other one and how happy they were to be friends. The next time they saw each other, they threw their diaries to each other.

'There you go,' Moon B said. 'I've written in it every single day. If you read a little every day you're away from me, you won't feel so bored and sad next year.'

'I'm so looking forward to it,' Moon A replied. His voice gave a little wobble, because he hadn't spoken for so long. They almost couldn't see each other now, so both moons started shouting 'Bye' and 'See you next year!' They began reading each other's diaries straightaway, but they soon realised that they'd both written the same thing: that it was so lonely and they had so many questions for the other moon. But now they had to wait a whole year for the answers.

And when they read, day after day, about how much they'd both missed each other, the two moons began to miss each other even more than before. They were so miserable that they both started crying and crying. And they carried on crying until they finally saw each other again. But to their great surprise, they realised that all that crying had made them smaller.

'No more crying,' Moon A said to Moon B, 'because there'll be none of you left and I really will be all on my own then.' They quickly swapped diaries again. They'd written lots of answers and more questions for each other. And, as they carried on spinning, they waved to each other until they disappeared from view again.

Both moons finished their diaries far too quickly. Reading was fun, for a while, but what they really wanted was to see one another. It wasn't long before they missed each other so much that they couldn't hold back their tears.

The next year, they almost didn't recognise each other.

'Who are you, you funny little pea?' Moon A called anxiously when Moon B came spinning by.

'I'm not a pea. It's me, your B.' Moon B sobbed. 'My sadness about you got bigger and bigger and I got smaller and smaller. Do you remember how big and beautiful we both used to be?'

They were so shocked by this that they forgot to exchange diaries. Now they had nothing to help them get through the year. Moon A and Moon B were inconsolable. They cried and cried and cried, until finally they were both so small that they dissolved into specks of dust that floated away to the stars.

DISCO
HEDGEHOG

long time ago, in the enchanted forest, a little hedgehog was born. His parents were terribly proud and had really been looking forward to their baby's arrival. They invited all the animals in the forest to come and admire their little one. Mummy Hedgehog baked cookies and Daddy Hedgehog gathered wood for an open fire so that it would be a merry gathering. Everyone was very impressed by the new baby hedgehog and they paid Mummy and Daddy Hedgehog lots of compliments.

'Oh, what lovely little prickles! Aw, they're still just a little bit soft,' said the rabbit.

And the swan sighed and said, 'He's already looking out at the world with such interest. He must be terribly clever!'

When the party was over, Mummy Hedgehog was very tired, but also very contented. She'd never received so many compliments before.

'Well, Daddy Hedgehog,' she said, 'shall we go to

bed now? Will you put out the fire?'

'That sounds good,' said Daddy Hedgehog and he gave his wife a kiss on the forehead. He blew out the fire and then it was dark in the little hedgehog nest.

But just as Mummy and Daddy Hedgehog were dozing off, they saw something peculiar. Something very peculiar indeed! Light was coming from the baby hedgehog's basket – a greenish glow that illuminated their entire nest!

'What's that?' Mummy Hedgehog asked, her voice shaking with fear. 'Do you think someone put something in his basket today?'

Together they went over to the baby hedgehog's bed. What they saw scared them out of their wits. Their own little baby hedgehog was giving off light as if he were a table lamp.

'Good heavens!' Mummy Hedgehog shrieked. 'That's impossible. I've never seen anything like it!'

'What a disgrace!' Daddy Hedgehog exclaimed. 'Whatever are the other animals going to say? We can't let anyone find out. We'll just have to keep him indoors once the sun goes down!'

'Oh, that's so sad,' Mummy Hedgehog said with a sigh. 'But if everyone's going to laugh at him, then it's probably the best solution.'

So that's what happened. They went to great lengths to keep Baby Hedgehog out of the dark. When the Hedgehog family went out for dinner, for example, and the sun was about to set, Mummy Hedgehog always pretended to have a headache. That way they could safely get back home before the sun went all the way down and Baby Hedgehog started to glow.

One time it almost went horribly wrong. There was

THEIR OWN
LITTLE BABY
HEDGEHOG
WAS GIVING
OFF LIGHT.

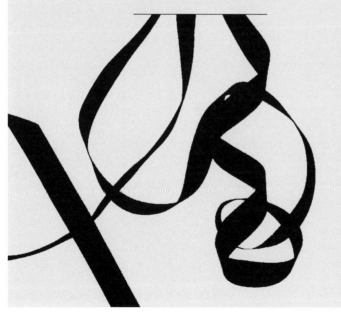

an eclipse during the animals' big annual picnic and
Mummy and Daddy Hedgehog didn't have time to hurry
back to their nest. Fortunately, everyone was staring up
at the sky in amazement, so they didn't notice what was
happening to the little hedgehog.

Mummy and Daddy Hedgehog hoped that the little
hedgehog's unusual attribute would go away by itself as
he grew older, but sadly that didn't happen. And then
came the day when the little hedgehog was not a baby
any longer and saw for himself that there was something
peculiar about him.

'Why do I light up like a lamp when it gets dark,
Mum?' the little hedgehog asked.

'Oh, that's just because you do so much thinking,'
Mummy Hedgehog said.

Of course that was a fib, because really there was
no reason at all. 'But don't let the other animals see your
light because they'll just think it's strange,' she warned
him.

The little hedgehog was scared that the other
animals would think he was weird, so from then on he
always hurried home as quickly as possible after school.
Then he would sit quietly, staring outside for a while, just
daydreaming. The only good thing about his green glow
was that he could stay up as late as he wanted. He had all
the light he needed to read by and to play games. When
Daddy Hedgehog came to make sure he was asleep, he
was always quick to pretend, but as soon as his dad turned
around, he went straight back to his book.

The little hedgehog would have stayed that lonely forever
if a particular incident hadn't turned his life upside down.

It was getting late one evening, but the little
hedgehog wanted to go and pick a bit of extra moss

before he went to bed, to make his mattress cosier. Ever so quietly, he tiptoed to the nearest tree, but all of the moss on that tree had already been picked. So, very cautiously, he looked around.

'It's so late. I'm sure there'll be no one about at this time of night. I'll just risk it and run over to the next tree,' he thought.

Luckily, the little hedgehog found lots and lots of moss nearby. But, just as he was about to turn around and scurry back home to curl up in bed, all cosy and warm, he had the fright of his life. In front of him, on the path through the forest, stood a black crow who had been pecking around after worms in the bushes. The crow stood there too, glued to the spot. Speechless with shock, they both stared at each other for a few seconds. The little hedgehog froze because he'd been caught out and the crow froze because, of course, this was the first light-emitting hedgehog he'd ever seen.

'Why on earth are you glowing like that?' the crow finally cawed.

'Because I do too much thinking,' the little hedgehog said quietly and he looked down at the ground in embarrassment. 'I know it's weird. That's why Mum and Dad always make me stay indoors at night. Promise you won't tell anyone. Please? Otherwise my mum and dad will be really angry and everyone else will just think I'm mad.'

The crow solemnly promised to keep his beak shut and then flapped his wings and flew away. The anxious little hedgehog hurried home and decided to say nothing to his parents.

Even though his bed was now very soft and cosy, the little hedgehog had difficulty getting to sleep that night.

The next day at school, everyone knew the little hedgehog's secret. The crow was a terrible gossip and he'd told absolutely everyone. All the animals came and stood in a circle around the little hedgehog.

'Ha ha, glowing in the dark, that's so weird!' one of them said.

'Is it catching?' another one asked, nervously.

The little hedgehog pretended he couldn't care less, but that afternoon on the way home from school, he started crying. 'Oh, how awful. Mum and Dad are going to be so angry,' he sobbed.

But when he got home, his mum and dad were actually very nice to him.

'We love you very, very much, you know, even though you are a little bit different,' Mummy Hedgehog said.

'We hoped no one would find out,' Daddy Hedgehog said, 'but there's nothing we can do about that now, so you'll just have to learn to live with it.'

The little hedgehog tried not to think about it too much. After all, thinking too much was exactly what made him glow in the dark, wasn't it? Later that night, when they'd finished eating dinner, there came a knock at the door. Mummy Hedgehog opened it. To her surprise, all the animals from the enchanted forest were standing there.

'Can we please see your little hedgehog?' the rabbit asked in her sweetest voice. 'We're very curious to see him glowing!'

All the other animals were peering over her shoulder. The little hedgehog looked at his dad with a question on his face. His dad gave him a nod. 'Go ahead, junior. Might as well get it out of the way.'

The little hedgehog shuffled reluctantly over to the door and went outside. He was greeted by a chorus of

'HA HA,
GLOWING IN
THE DARK,
THAT'S SO
WEIRD!'

'ooohs' and 'aaaahs'. He stared shyly at a ladybird who was scuttling past and tried, as hard as he could, not to think about anything at all, but still he couldn't help giving off light.

'Well, it's a bit weird,' pondered the badger.

'It's weird and wonderful!' whooped the swan.

'Hey, it must be handy if you lose your way in the dark,' croaked the frog.

'He looks just like a disco ball!' squeaked the mouse.

And so it went on for a while, until the little hedgehog became sleepy and Mummy Hedgehog sent everyone home. The animals returned to their own holes, nests and houses, chattering as they went.

When the little hedgehog went to bed that night, he felt very pleased that the other animals had said so many nice things about him. He also realised that he didn't have to stay at home in the evening any more. After all, everyone knew his secret now, didn't they? Daddy and Mummy Hedgehog came in to give him a goodnight kiss and told him how proud they were of him.

His life was as hectic now as it had been quiet before! Whenever anyone got lost in the dark, everyone called him to go and search for them, and if a fuse blew somewhere, the little hedgehog had to go and provide emergency lighting. Suddenly, everyone needed him for something.

One day the gossiping crow paid the little hedgehog a visit. He had a plan: if they put on a disco in the middle of the enchanted forest, the hedgehog could stand in the centre of the dance floor and light up the party. What did he think of that idea? Although the little hedgehog was still rather annoyed with the crow for giving away his secret, he thought it was a good plan. Maybe he'd even make

some friends at the disco. Because even though everyone needed the little hedgehog now, he still felt just as lonely as he did before. No one ever spoke to him. All they seemed to be interested in was his light. The crow's idea might just change all that.

The first disco was a complete success – finally there was somewhere exciting to go in the enchanted forest. And from that moment on, the animals in the forest called him Disco Hedgehog. Night after night, Disco Hedgehog was now the shining light in the middle of the dance floor. While he stood there all night, everyone danced happily around him. But still no one came to speak to him and so Disco Hedgehog just started to worry more and more.

'All this thinking means I'll never be normal,' he thought, 'and what I want most in the world is to be normal. Now everyone just sees me as a disco light.'

Disco Hedgehog persevered with his job at the disco for weeks. Sometimes he tried to join in with the dancing, but everyone always shouted at him to stay where he was because he was spoiling the light show. And, of course, now he never had any time to read.

One night, when everyone was dancing around him, Disco Hedgehog suddenly felt so exhausted that he fell from the stage the other animals had built for him. A few kind animals carried him back home, where a worried Mummy and Daddy Hedgehog put him to bed.

No one understood what had happened.

'Maybe he thinks his stage isn't high enough,' the frog grumbled.

'Or perhaps he doesn't want to be our friend any more,' the mouse squeaked suspiciously.

'Ah, so he was your friend, was he?' said the clever swan. 'We all thought it was really useful and great fun, the way he shone like that and lit up the disco, but none of

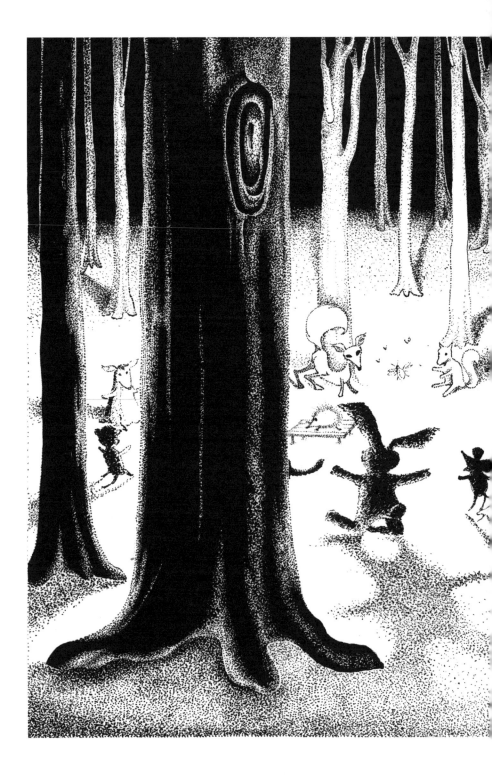

us ever said a word to Disco Hedgehog!' It was true.
The animals all looked guiltily down at the ground.

'How awful,' they thought, as they remembered all
the fun nights they'd had, thanks to Disco Hedgehog's
light.

For a while there was silence, until the crow finally
cawed, 'I have an idea!' He actually felt very guilty now
that he realised what he'd done to Disco Hedgehog.
Excited, all the animals gathered around him and listened
closely to his plan.

The next day the crow went to Disco Hedgehog's house.
Daddy Hedgehog stood in the doorway and eyed him
suspiciously. Disco Hedgehog was still in bed and didn't
want to see the crow.

'But we have a big surprise for him,' the crow cawed
to Daddy Hedgehog.

'What you mean is you need some light,' Daddy
Hedgehog said sternly.

'No, honestly, we really don't. Can I please speak to
him and explain?' the crow begged.

Then Disco Hedgehog peeped around the corner,
actually rather curious to see what the crow had to say.

'Come to the disco tonight. We have a surprise for
you!' the crow squawked. Having delivered his message,
he took to the sky.

That night the little hedgehog went to the disco, curious
to find out what was going to happen, but, to his
disappointment, the place was deserted.

'That's strange,' Disco Hedgehog thought, 'has that
crow let me down again?'

His little hedgehog heart sank at the thought.
Forlornly, he shuffled from side to side, then sniffled a

'BUT WE HAVE
A BIG SURPRISE
FOR HIM.'

bit and felt the tears slowly welling up in his little eyes. But just as he was about to go home, one thousand lights suddenly came on, all at once. It was like a starry sky on a clear night. Such a beautiful sight! Disco Hedgehog rubbed his eyes to make sure he wasn't dreaming. Everywhere he looked, there were lamps bobbing about. When he looked more closely, he saw animals from the forest holding each of the lights. Some had candles, others had lanterns. The crow had even dragged along an entire Christmas tree with a hundred fairy lights on it! All the lights combined were glowing so brightly that Disco Hedgehog couldn't even see his own light. He was just like all the other animals!

Then everything went a bit blurry and two tears of joy rolled down his cheeks. For the first time in his short life, he no longer felt strange and isolated. All the animals came over for a little chat and told him how much they appreciated him. Then they all started dancing and Disco Hedgehog happily joined in and had the best night of his life.

When he finally got home, he realised he hadn't done any thinking all night. He'd been too busy having fun with his new friends! He told Mummy and Daddy Hedgehog all about it and said that, from then on, he never wanted to do any more thinking.

'Oh dear,' Mummy Hedgehog said sheepishly, 'that's my fault. I'm the one who said that you glow because you do too much thinking. How awful! I only said it to make you feel better. Everyone thinks about things all the time. We're just delighted that you're such a bright little hedgehog – and such a very special little hedgehog too!'

'What a day,' Disco Hedgehog thought. 'It seems I'm just like all the other animals, even if I do give off light!' And, actually, that light of his came in very handy indeed.

Disco Hedgehog climbed into his bed of moss and took a good look around his illuminated bedroom.

'I'm so happy,' he whispered to himself, before falling into a deep, deep sleep.

THE
GOLDEN
DRESS

n a far-off land, there once lived a very pampered little princess. Her name was Giselle. She had everything you could ever imagine, not once, but ten times over. The palace seamstresses made the most beautiful clothes especially for her – ten of everything. She owned ten of every single toy there was, but still she complained that she had nothing to play with. The palace cook never knew what to make for her next. One day she would eat only peanut butter, but the next day she would have only strawberries. Every day she came up with a new favourite food for the cook to make, but she never, ever said thank-you or told him how much she'd enjoyed it.

Her impossible behaviour was driving the king crazy, so one day he gathered his servants together to help him find a solution. All he wanted was to make his daughter happy. Giselle was, after all, his only child. The queen had died when Giselle was just a baby and the spoilt little princess was all he had to remind him of his beautiful wife.

The servants didn't know how to make the princess happy. They'd already tried everything to please her. Secretly, they were actually starting to dislike Giselle. But they loved their king very much and wanted nothing more than to see him happy.

One day though, the king's chamberlain suggested a plan that he suspected the king and the princess would like. What if the king were to organise the biggest party

ever, especially in honour of his daughter? She would be the centre of attention. The princess was sure to think it was a wonderful plan – particularly when she heard she was allowed to design her own dress. The chamberlain had already discussed the matter with the palace seamstresses and agreed that the princess could dream up whatever dress she wanted to wear and, no matter how crazy the idea might be, the seamstresses would make it for her.

The king thought this was a marvellous suggestion. He quickly ran to the princess's chamber and knocked on the door. You couldn't just go straight into Giselle's room. No, first you had to announce your presence and then, if you were lucky, she would open the door. Even the king had to obey the rule. The door opened a crack and Giselle's face appeared. She had long, wavy blonde hair, green eyes, a dainty tip-tilted nose and a round little face, but not even a hint of a smile for her own father. She looked down her nose and asked the king if he could keep it as brief as possible.

The king told Giselle that he wanted to give the biggest party ever, especially for her, that she was allowed to wear whatever she wanted, and she would be the centre of attention. The princess gave a deep sigh and told the king she'd think about it. She slammed the door shut and asked her chambermaid what the most precious thing in the world was. The chambermaid thought about the king's crown. She couldn't imagine anything more beautiful, so she knew what her answer was. 'Gold.'

The princess opened the door again and told the king, who was still waiting patiently, that she wanted a dress made entirely out of gold. Only then would she come to the party.

When the seamstresses heard about the princess's request, they panicked. They didn't have that much gold in

THE KING TOLD
GISELLE THAT
HE WANTED TO
GIVE THE BIGGEST
PARTY EVER...

THEY CHECKED
EVERY HOME
TO MAKE SURE
NO ONE WAS
HIDING ANY GOLD.

the palace. All the gold in the entire kingdom would have to be melted down so that they could weave a dress from threads of pure gold. The king was shocked when he heard this news, but he didn't want to disappoint his daughter so he pressed on with the plan.

The next day, it was announced throughout the kingdom that all the king's subjects had three days to hand over everything they had that was made of gold, because it was needed to make the princess's dress. Well, you can imagine that there was a huge outcry all over the land! The people were angry about losing their precious possessions, but the king's servants were very strict. They checked every home to make sure no one was hiding any gold. People handed over their wedding rings, gold watches, gold brooches, gold picture frames, gold earrings, and whatever else they had that was made of gold. Even the ancient church bell from the capital itself had to be melted down, because it too was made of gold.

The king's goldsmiths turned all of the molten gold into thread and delivered the thread to the palace weavers. The weavers found it very difficult to make the cloth of gold, because it wasn't easy to work with and gave them nasty blisters. Giselle regularly popped in to check that the fabric was beautiful enough and that all the threads really were made of pure gold. She bit the fabric and if the consistency was right, she knew it was real gold. She also wanted all the buttons to be made of gold and she stamped her foot impatiently when she heard that they weren't ready yet. Her face red with rage, she headed back to her chamber to eat bon-bons.

The servants told the king that his subjects were angry about having to hand over all of their gold, even though everyone knew it was for the king and they loved him very much. The king sighed and said he knew he'd

disappointed his people, but he remained firm. He hoped that when the people saw Giselle shining in her golden dress, they would all cheer and applaud and understand why they had been ordered to sacrifice their valuables. The king was determined to make sure that the party was an unforgettable one for his subjects too.

And the king was right. On the big day, the day of the biggest party ever, the sun was shining, the birds were singing and the palace was decorated with thousands of flowers. The king provided the most delicious cakes and the very best wine for his people. There was singing and dancing and everyone was having a wonderful time.

Then the king presented the little princess with her beautiful new dress. He told her how much he loved her and said how sorry he was that she had no mother. And he said that everyone in the kingdom had made a sacrifice and given their own gold for her dress.

Giselle wasn't really very interested in her father's speech. She just wanted to put her dress on – and quickly! The dress was so heavy that it took five servants to slip it on over her silk petticoat. Giselle had to admit to herself that was the most beautiful dress she'd ever seen, but of course she didn't say that to anyone. The dress had big puff sleeves and a voluminous skirt with a beautiful floral design. Finely woven gold ribbons seemed to float around the bodice. For a moment, the dress overwhelmed Giselle and she thought she was going to fall over, but she managed to stay upright. It wasn't long though before she started to sweat and her back began to hurt. Still, what she wanted more than antything else was to show her dress to the celebrating crowds to make them feel jealous. The servants helped her to the balcony and warned her to be very careful with the dress as it was terribly fragile.

Twenty-five trumpeters announced the arrival

THEN THE KING
PRESENTED
THE LITTLE
PRINCESS WITH
HER BEAUTIFUL
NEW DRESS.

of the princess. Ta-ta-ta-tata-ta-da! And it worked: the entire kingdom looked at the princess. Everyone stopped celebrating and silence descended upon the town. The sun shone brightly upon the gold and the light reflected off it in every direction. It was as though the sun had come down to visit the palace. Thunderous applause broke out. The people said to one another that they'd never seen anything so beautiful and they were proud to have made a contribution to such a lovely work of art.

Giselle, however, had had enough of the dress by then. It really was very heavy indeed. Everyone's down there having fun, she thought, and here I am, sweating away. The longer she thought about it, the angrier she became. She completely forgot that she was so pampered and spoilt that a dress made of gold had been all her own idea. How dare those commoners do this to her! She was furious. In a fit of anger she pulled off the golden dress and kicked it down the stairs. The dress crumpled and tore. All that gold – all that hard work – had all gone to waste. The king paled as shock rippled through the crowd. Was this why everyone had sacrificed their gold?

Giselle was only half aware of what she had done, but she saw that the crowd's admiration had turned into fury and hate. She glanced over at her father and was shocked to see big, fat tears rolling down his cheeks.

Giselle realised she'd gone too far this time. A couple of servants quickly spirited the princess back into the palace. Slowly it dawned on her how very badly she had behaved.

The king addressed his subjects. With a sob in his voice, he confessed his shame at his daughter's behaviour. He promised the people that he would give Giselle a fitting punishment. Finally, Giselle was going to see the consequences of her bad behaviour.

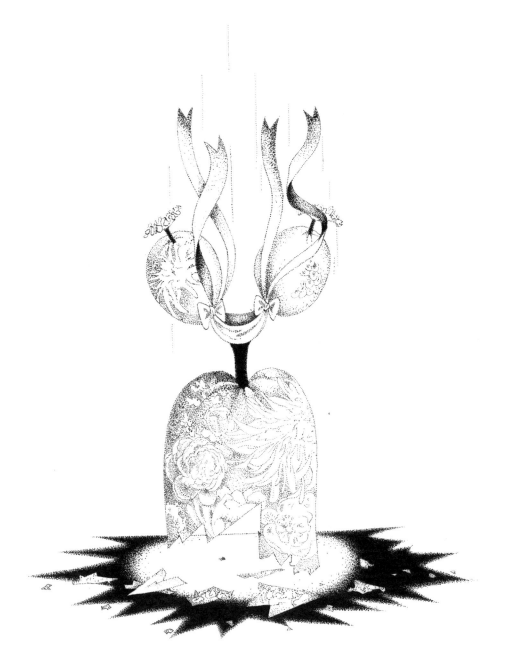

Later that evening, the king walked into the princess's chamber without knocking. He told her that he had a punishment in store for her that she wasn't going to forget in a hurry. She was going to be sent to a poor farming family to work for them until she had earned enough to buy a gold hairpin with her own money. Maybe then she would understand the sacrifice that the people of her country had made for her.

Giselle, who had no notion of the value of gold, thought that the punishment didn't sound too bad, all things considered. After all, it was only a gold hairpin. That wouldn't take long, she thought. Full of relief, she fell asleep.

The next day, one of the king's servants took the princess to the farm. She was disguised as a maidservant so that no one would recognise her. The servant told the peasant woman, who lived alone with her two daughters in the remote farmhouse, that the king had sent her a maid to help the family. The woman felt very honoured. She explained that she needed the help because her two daughters were seriously ill and she'd had to do everything on her own for months. She said Giselle could start immediately. The princess had never had to do any work in her entire life, so she didn't know what the woman meant when she told her to 'wash the dishes' or 'tidy up'. The peasant woman soon realised that Giselle had a lot to learn.

At the end of her first day of work, the princess felt very proud of herself. She had worked hard for a whole day. Now the king would see how sorry she was for her ungrateful behaviour. When dinner was on the table, she asked the peasant woman if she'd earned enough to buy

GISELLE, WHO HAD NO NOTION OF THE VALUE OF GOLD, THOUGHT THAT THE PUNISHMENT DIDN'T SOUND TOO BAD...

a golden hairpin yet. The woman laughed out loud and told her that would take about a year. Giselle couldn't believe her ears. She sobbed as she took dinner up to the two daughters, who lay together in a big old bed up in the attic. It was the first time Giselle had seen the girls and she was shocked at how pale their little faces were. Maria and Theresa had been in bed for months, suffering from shiveritis, a dreaded disease that made them shiver all the time. Nothing could warm them up and the doctor was scared they were going to die. Giselle sighed and thought she might as well catch shiveritis herself, because not one single hair on her head intended to stay here and work for a whole year. But she pulled herself together, fed Maria and Theresa their soup and stayed talking to them for a while – it wasn't as if she had anything better to do. The two sisters were happy to have a visitor and they told the princess all kinds of stories about life on the farm. Sometimes one of them had to finish the other's sentence because she was shivering too much to speak.

As Giselle was taking the soup bowls back downstairs, she came to a decision. She was going to run away. She would simply return to the palace. However, when she went outside, she realised that the farmhouse was in such a remote region that she had no idea which way to go. The disheartened princess didn't much fancy getting lost and starving to death, so she headed back into the farmhouse. She'd have to try to make the best of it.

The next morning, she made breakfast and headed upstairs to see Maria and Theresa again. They asked her if she had any nice stories to tell them about her life. Giselle thought for a long time and realised that she didn't actually have any nice stories to tell at all, because she'd always been so dissatisfied. She looked at the shivering sisters and the thin porridge in their bowls and thought about the

palace cook and all the delicious cakes and pies he could have baked for the girls.

And that was Giselle's life, day in, day out. During the day she worked on the farm, so hard that she had blisters on her hands. And every evening she sat with Maria and Theresa.

A few months passed and she became so close to Maria and Theresa that they treated her as though she was their sister. They told Giselle how grateful they were for the way she helped their mother around the house and how much they appreciated the food she prepared for them every day. They didn't know how they would cope without her, they said.

Giselle slowly began to realise just how pampered she had been and how ungratefully she had treated everyone. She thought about the lovely cook who'd always made whatever she wanted and how hard he had worked to please her. And whenever she thought about the golden dress, she felt so ashamed that she went bright red and sometimes didn't speak for hours. All I can do to make amends is to take good care of Maria and Theresa, she thought. So she started to research the dreaded disease shiveritis and found out that it had something to do with nerves. It was true, thought Giselle, that when she gave Maria and Theresa camomile tea and talked to them for a long time, the two sisters seemed to shiver less.

So she needed to make sure that Maria and Theresa were kept as calm as possible. They had to be distracted from their worries. Giselle applied herself to the task. She came up with a list of ideas to entertain the sisters. She played games with them, read stories, made their food as delicious as possible, padded their mattress with fresh hay, and made sure they always had a fresh pot of camomile tea.

The girls' mother, who had never had enough time

to take such good care of her daughters, wondered where this angel had come from. Giselle's nursing and attention slowly helped the sisters to recover.

When spring arrived after a long winter, one of the king's servants came to fetch Giselle. She had been working on the farm for exactly one year. Giselle sobbed as she said goodbye to the girls and their mother, because she had started to see them as her family. At the palace the king was looking forward to his daughter's return. He only hoped she'd learnt her lesson. When she saw him, Giselle fell into her father's arms and gently sobbed. She thanked him for his wisdom and promised that she'd changed her ways. The king had never been so happy. He presented his daughter with a golden hairpin to show her how pleased he was.

But Giselle didn't want to keep the hairpin for herself. 'I'd rather give my hairpin to my friends at the farm. They need it more than I do.' She also announced that she wanted all of her dresses and toys to be sold so that she could pay back some of what she owed the people for all that gold. The king asked her if she wanted anything for herself and she replied that she would love to have Maria and Theresa and their mother join her and live in the palace as her friends.

Then she explained to the king that she had once thought gold was the most precious thing in the world, which is why she'd asked for a golden dress. But, finally, she had learnt that the most precious thing in the world isn't gold – it's friendship.

THE CIRCLE AND THE SQUARE

A circle is round and a square is ... well ... square, with four corners.

And, once upon a time, a famous architect decided to put a circle and a square into one of his designs. From the moment he put them down on paper, the two shapes couldn't stand each other. The circle thought the square was terribly sharp and pointed and the square thought the circle was too much of a smoothie. Both shapes thought that the drawing would have been far better if the other shape had not been in it. So, as far as they could, they avoided looking at each other. Very occasionally, when they absolutely had to, they deigned to glance at the other shape, but they both remained as haughty and distant as possible.

'What is that circle doing in my drawing?' thought the square. 'I'd rather have a few more squares instead. That would be so much more fun.' The square had forgotten that it wasn't actually his drawing at all.

'Confound it!' the circle was thinking at the same

time. 'That square is messing up the entire composition. I would look so much more elegant on my own.'

It was days before they actually spoke to each other. When that day finally came, what the circle said was, 'I say, Square, could you please move to another drawing? I find your presence here really rather annoying.'

The square sniffed in indignation. 'Well, that really is rich,' he snapped. 'If anyone should leave, it's you. You're ruining my view.'

'Ha ha,' the circle scoffed. 'I don't think so. This is my place and I'm going to stay right where I am!'

Neither of the two was prepared to give in, so they both stayed. The circle simply couldn't understand why something as crude as the square even existed. And the square was hopping mad about that nasty, stuck-up circle. Each of them was convinced that he was better and more beautiful than the other shape, so they just carried on sulking and spying on each other.

The feud reached a climax when the square tried to push the circle out of the drawing. He poked at the circle with his corners. The circle reacted by bouncing at the square and trying to force him off the drawing. Neither of them succeeded. They just ended up hating each other even more. The atmosphere on the sheet of paper was becoming increasingly unpleasant.

One day, the square decided he'd had enough. If he couldn't take up the whole drawing, he could at least have exactly half of the paper, couldn't he? So he banned the circle from his half of the drawing.

'And what exactly is your half, if I might ask?' demanded the circle, glaring at the square. 'Whatever it is, it had better not include the top left corner, because that's my favourite corner.'

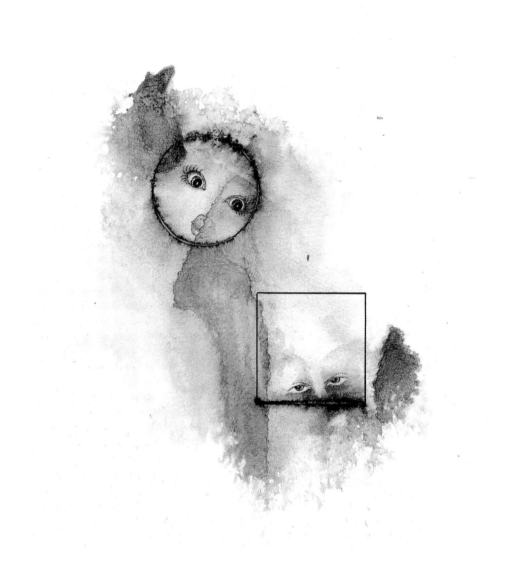

'I WAS SO BEAUTIFUL
AND PERFECT. LOOK
AT THIS! I'M LOSING MY
LOVELY SHAPE!'

'What a coincidence,' snarled the square. 'That's my favourite corner too.'

And the two shapes started to argue again.

Eventually, the atmosphere in the drawing was so bad you could have cut it with a knife. The architect, who of course knew nothing about the feud between the two shapes, wanted to do some more work on his drawing, but he was shocked to see that the two shapes were no longer where he had put them. So shocked, in fact, that he knocked over a glass on his drawing table. Water ran all over the paper.

The circle could feel himself getting soaked and he cried out to the square, 'Oh, here we go again! Why am I all wet instead of you? I was so beautiful and perfect. Look at this! I'm losing my lovely shape!'

The square thought this was most amusing, and was about to start laughing at the circle, but then he realised he was wet too. His corners were fading and he was starting to look a little round. The horror!

'Oh no, look at me!' he called out to the circle. 'There go my beautiful corners. I'm going to be just as round as you!'

The two shapes sat there, grumbling away, and trying with all their might to keep their lovely lines intact. But the puddle of water was so big that the ink had run all over the paper.

'Oh, all of this dampness is going to give me such a bad cold,' wailed the square.

For the first time, the circle showed a little sympathy and said, 'If you get a cold, I'll make you some soup.'

Even though he was so wet, the square burst out laughing. 'Well, don't spill any soup over me!' he said. 'You'll make me even rounder!'

The two shapes chuckled at the thought. Until the

circle suddenly gasped, 'Look, Square ... You're getting bigger and bigger and you're fading away! And so am I!'

'Yes, I can see that,' the square cried. 'Look, our lines are merging together.'

And the circle and the square slowly, slowly dissolved. Their outlines blurred and they gently flowed into each other until they were just one hazy patch of grey. The circle and the square could do nothing to stop it. And it was only when the architect exclaimed, 'What a magnificent picture!' that the two shapes realised they'd always belonged together.

CHRI.TMA

*Y*ou know what it's like when a letter on your keyboard stops working or a button falls off your new shirt? Annoying, isn't it?

Well, there was once a boy called Simon, who couldn't say the letter S. No matter what he did, however hard he tried, whenever he tried to say S, not a sound came out of his mouth. The Z and the P, the T and the G, they all sounded perfect. It was just S that wouldn't come out of his mouth, even though he practised and practised. It really irritated him. He couldn't even say his own name. He just used to say, 'Hi, I'm Imon.' 'Strange name,' people would think, but then there are lots of strange names out there. Some people even call their children after fruit and veg or their favourite colour and, when you think about it, Willy's a pretty funny name too.

But in a conversation, Simon couldn't keep his handicap hidden. So he usually said as little as possible and tried to avoid words with the letter S in them. It often

worked fine. When he wanted to say 'What a bad smell!', for example, he'd just say 'What a nasty niff!' instead. But, of course, he couldn't always find an alternative. There's no other word for 'Christmas', for instance. So Simon always had to call it 'Chritma'. And, every year, when that time of year came around and he made his Christmas wish-list, he always wrote that he wished he could pronounce the letter S properly, even though he knew that wasn't the kind of thing you usually get as a Christmas present.

Anyway, one Christmas, Simon was feeling a bit stressed (although he had to say he was 'worried' instead). He had to write a Christmas poem and he wasn't very good at rhyming. And the worst thing was that everyone was expecting him to read the poem out to the whole family. It was tradition. Every member of the family had to pull a name out of a hat and write that person a Christmas poem and buy them a special present. This year Simon had drawn the name of ... his aunt Sissy. Or, to address her by her full title: Aunt Sissy Sassoon-Sissinghurst-Smythe. You can imagine what a problem all of those annoying sss sounds were for Simon. Of all the people in the family, why had he pulled Aunt Sissy's name out of the hat? Talk about bad luck!

Now, you also need to know that Aunt Sissy wasn't just any old aunt. Aunt Sissy was a witch. She lived in a strange yellow house in a dark forest and she collected snakes. She was crazy about the creatures. She had ten of them and they all accompanied her wherever she went, which made her rather unpopular with the rest of the family. And she really disliked Simon's mother, her sister. Just to annoy her, she'd put a wicked spell her first-born baby when he was born. Yes, that was Simon. When Aunt

Sissy was left alone with baby Simon for just a moment, she recited the following magic spell:

By my snakes' delicious hissing
This baby's S will now go missing

Then she ran off, cackling. As his mother and his aunt didn't get on, Simon had only visited Aunt Sissy once in his entire life. The hissing of the snakes had scared him stiff.

And now the whole family was coming together to celebrate Christmas and to try to let bygones be bygones. He decided to buy Aunt Sissy some mice for her Christmas present, because he knew that snakes are fond of mice. And if the snakes were happy, then Aunt Sissy was sure to be happy too, thought Simon.

He felt rather sorry for the mice though. He spent ages in the pet shop, wondering which mice to buy. They all looked so sweet and they looked at him so longingly. They obviously wanted to get out of the tiny cage in the pet shop and were all hoping for Simon to feed them with cheese and keep them in a lovely big cage. They had no idea about the terrible fate that was actually in store for them. Simon could tell what they were thinking and it made him feel very uncomfortable, but he didn't have much time and he really couldn't come up with any other bright ideas for a Christmas present for Aunt Sissy. So, finally, he chose just a couple of the very tiniest white mice and went home to work on his poem.

Dear Aunt Sissy,

he wrote. Oh no, thought Simon, that's going to come out as 'Dear Aunt I-ee'... I'd better just keep it 'Dear Aunt'.

'NOW OPEN
THE GIFT,
TO YOU
FROM ME'

Dear Aunt,

I've really missed ... erm, oh no ... What a shame ...
erm, What a pity that we haven't seen ... no ... What
a pity that you haven't been here.

But your ten snakes, oops ... your pets ... oh no ...
your reptile gang, um ... fill me with fear.

I know what they like to eat,
Good and tender rodent meat ...

As already mentioned, Simon wasn't very good at rhymes.
You can see that for yourself now. He had no idea what to
write next. 'Oh, this is awful,' he thought, 'and I've hardly
got any time left now.' So he quickly scribbled down the
rest of the poem:

Now open the gift, to you from me,
A yummy Christmas treat. And bon appétit!

He finished the poem just in time. The doorbell rang
and the first guests arrived. When Aunt Sissy Sassoon-
Sissinghurst-Smythe arrived from her strange yellow
house, bringing her beloved snakes in their travelling tank,
Simon's family began what everyone else thought was the
most fun part of the evening: handing out the presents and
reading the poems. Simon was so nervous! When it was
his turn, he picked up the box of mice and cleared his
throat.

The two little mice in the dark box were very excited
indeed. What was going to happen? They could see a
huge Christmas tree through one of the air holes. They'd

never heard the word Christmas, of course, but they knew that something special was going on because the humans had brought a tree into the house. And they knew that a tree in the house meant there'd be lots of tasty crumbs on the floor for them to nibble, because humans always ate a lot on the special occasion when there was a tree in the house. The Time of the Tree was a very big deal in Mouseland and generations of mice had always looked forward to it. So the mice paid close attention and listened carefully to Simon's poem. But they nearly jumped out of their furry little skins when they heard what he said!

> *What a pity that you haven't been here,*
> *But your reptile gang fill me with fear.*
> *I know what they like to eat,*
> *Good and tender rodent meat.*
> *Now open the gift, to you from me,*
> *A yummy Chritma treat. And bon appétit!*

A yummy treat? Rodent meat? Did he mean them? And what was the reptile gang he mentioned? And what on earth was Chritma? They uttered squeaks of terror. When Simon said 'Chritma', the whole family laughed. Aunt Sissy laughed loudest of all and she gave him a really mean, mocking look. Simon felt really miserable. Why hadn't he read his poem through again properly? And said it out loud? He'd have spotted his mistake immediately!

'Chritma, Chritma, it's Chritma today! Happy Chritma, everyone!' The family just kept on repeating it. Simon quietly blushed and looked over at the snakes. They were upright in their glass tank, swaying their heads and staring at him hungrily. Perhaps Simon was imagining it, but even the snakes seemed to be laughing. Suddenly he hated everyone in the room. He hated his whole family

A YUMMY TREAT?
RODENT MEAT?
DID HE MEAN THEM?

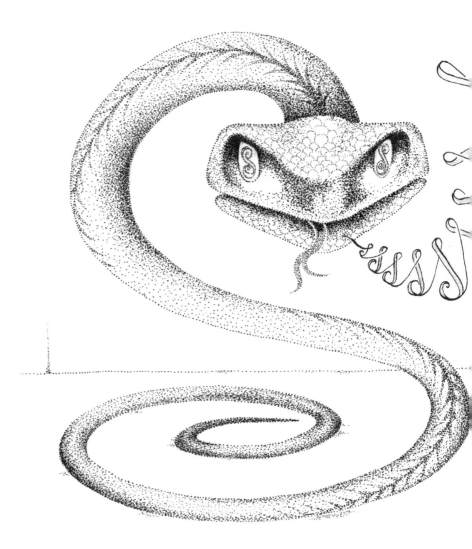

for laughing at him and he hated the snakes most of all!

When Aunt Sissy had finally recovered from her laughing fit, she sneered at Simon and said, 'Imon, why don't you feed the Chritma mice to my little treassssures?' She opened the lid of the snakes' tank and gave Simon a little shove in his back.

Simon looked down at the box. Through one of the air holes, he saw a little mouse looking up at him with pleading eyes. He heard a very quiet voice say, 'Please, kind little boy, please don't give us to those nasty snakes. It's Chritma, we want to celebrate Chritma too, just once. We've never had Chritma before!'

Shocked, Simon stared into the box. Did he hear that right? Did the mouse say 'Chritma'? Was the little mouse taking the mickey out of him too? But when he saw the terrified face of the shivering mouse, he could see that it really, genuinely thought they were celebrating 'Chritma'. For the first time in his life, Simon laughed a little bit at his own speech defect. And he felt really sorry for the little mice, all over again. Then he made a decision: those snakes, Aunt Sissy and his whole family could all take a running jump! He was going to look after the little mice. There was no way he was going to feed them to those snakes!

His mind made up, he stared at the snakes' tank with narrowed eyes. And then something very strange happened. The snakes seemed to be trying to hypnotise him. The whole room fell still. It sounded as though the snakes were saying, 'Sssssimon, give ussss the sssnacksssss, the tasssty mice. Sssssnakesss want mice!'

'No.' Simon declared. He was feeling a bit dizzy from all that hypnotic hissing, but he held firm. 'No, I won't give them to you. Clear off, you long, thin, creepy bunch!'

But the snakes all stuck their heads up out of their tank and stared right at him. The biggest one slithered over to Simon and, bringing its head up level with Simon's, it said, 'Sssssssssssssssssssssssssssssimon, lissssssssssssssssten clossssssssssely. I have an offer you can't refusssssssssssse. If you give usssss thosssssse tasssssssty mice, we will give you back ... your sssssssssssssssssssssss!'

Simon blinked. 'What? You'll give me back what?'

'Your ssss, ssssstupid boy. You can have your sssss back for Chrissssssstmassss, so you can finally ssssssspeak properly, Sssssimon.'

Simon gulped. Had he heard it right? His dearest wish! No one would laugh at him ever again ... He looked at the mice. To his horror, he saw that he'd already opened up the box. The hypnotic snakes almost had him in their power. The two mice were huddled together, shivering in the corner of the box. They'd shut their little eyes. What was he doing? Simon shook his head in confusion.

'No!' he shouted with all his might. 'I won't do it! I don't care if I can ... make that ... letter or not! If you think I'll give them to you, you are tunningly tupid!' He slammed the lid back on the box and turned around to make a run for it, but two clammy hands seized him by the shoulders.

'Where are you off to, nephew?' Aunt Sissy hissed in his ear. 'Not ssso fassst ... Won't you give me and my treasssssures our Chrisssstmasss presssent before you sssscarper?'

But Simon had made up his mind. He turned the box of mice upside down. 'Quick! Run like the wind! I might not be able to utter that letter, but no way am I going to hand you over!'

The two little mice jumped out of the box and ran as quickly as they could to the nearest wall, where they

luckily found a hole to escape through, away from the hungry, hissing snakes and away from Simon's squabbling family.

For a long time after that, the two mice told any other mice who would listen all about their big adventure. And those mice told the story to any other mice who would listen to them. And since then the Time of the Tree has been known as Chritma to all mousekind – which is how Chritma came to Mouseland.

And when they're sitting there, happy and fat, with their tummies full of tasty crumbs, the mice all chorus together: 'Happy Chritma!'

If only Simon knew!

FLOWERBOMB

War had come to the land. Before the war, the land had been enchantingly beautiful. Back then, there were green hills wherever you looked and meadows of flowers in every colour of the rainbow, as far as the eye could see. And the ocean was a magnificent shade of deep blue.

No one could remember exactly how it had started, but the war had been going on for a long time. The land was grey and filthy now and the sea was black. The hills were swathed in smoke from the bombs and most of the trees and flowers had withered and died. It was a sorry sight.

All the bombs that were needed for the war were made in Mr Cash's big factory, on the orders of President Black. Mr Cash didn't think about the people in the land or about beautiful things. All he thought about was money. The bombs he made were big, round balls filled with

gunpowder and with a fuse sticking out of them. Every day, Mr Cash walked proudly around his factory, checking his bombs. 'Ha ha,' he laughed out loud. 'You little beauties are making me rich!'

All the bombs knew was that they'd been created to destroy the land. 'Oh,' they sighed to one another, 'this is such a palaver. Quickly, just light my fuse and then at least it'll all be over and done with.'

And that's how it went, year after year. Until one day, when Mr Cash was ill in bed with the flu. That day, something remarkable happened.

For a long time, one of the factory workers, whose name was Frank, had been dreaming up a little plan to do something about that nasty war. And now that Mr Cash was ill and there was no one to check the bombs, he could finally carry out his plan. Like most people, Frank had had more than enough of the war. He wanted to be able to enjoy all of the beautiful things in the land again. What if he came up with something to remind people how beautiful it had all been before? Wouldn't it make them want to try their hardest to stop this pointless war?

For weeks, Frank had been picking every stray flower he'd found among the rubble. He had saved a great big pile of them and that day he secretly filled one of the bombs with his flowers instead of gunpowder. He gave the bomb a little stroke and whispered, 'Hello there, Flowerbomb, all of my hopes and wishes are with you. Please, please, choose the perfect moment to let your beauty come bursting out!'

The Flowerbomb knew it had a special mission, even though it didn't understand exactly what Frank meant.

Let's fast-forward a little here, because it would take too long to explain how the Flowerbomb was packed up and

96

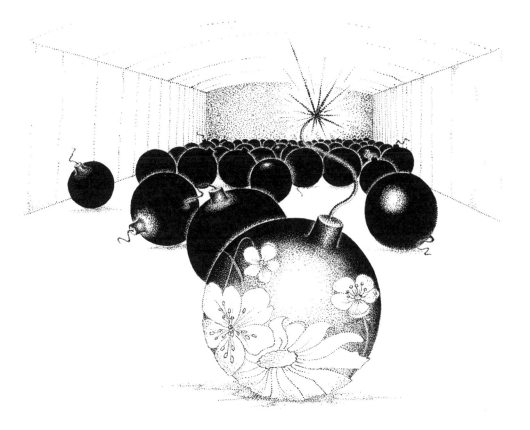

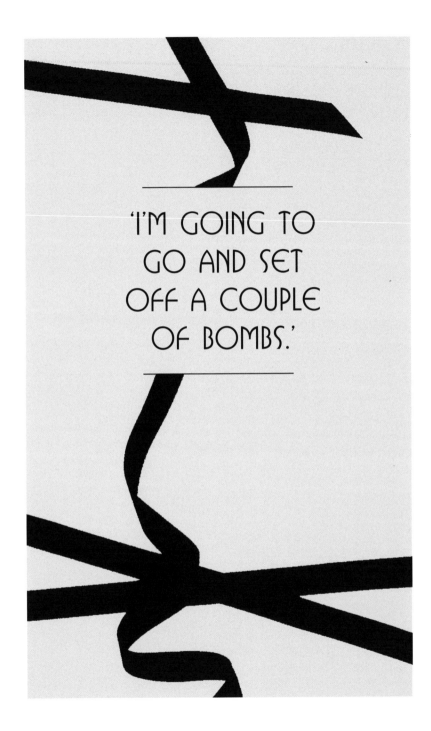

'I'M GOING TO
GO AND SET
OFF A COUPLE
OF BOMBS.'

transported to the presidential palace. And it's not really very important. President Black, on the other hand, was very important indeed – or at least that's what he thought. Of course, presidents are important, but unfortunately they're sometimes very stupid too. And President Black was one of the very stupid ones. In fact, he was very, very stupid. He refused to do anything at all that might help put a stop to the war. That's because he was scared that people would no longer need him when the war was over.

'I'm going to go and set off a couple of bombs,' the president said to his ministers. 'That'll keep people busy for a little while.'

A clever minister, Minister Bright, said, 'Anyone would think you enjoy setting off bombs.'

'Of course not, Ms Bright,' the president exploded. 'And where did you learn to be so impudent?'

Minister Bright sensibly bit her tongue.

President Black took his cigar from his mouth and lit the fuse of the first bomb within reach. 'Ha ha,' he laughed as he threw the bomb into the garden where the ministers were sitting. They were all shocked out of their wits and ran away screaming. The bomb exploded, turning the garden black.

'That really is the limit!' Minister Bright sobbed. 'I'm so tired of all these bombs and the war too! I want to see beautiful things again!'

'What? Whaaat?!' screamed the president. 'That's enough! I've had it with you!' He took the cigar from his mouth again and picked up another bomb.

'Yeah, go ahead and light my fuse, you stupid president,' thought the Flowerbomb. 'I'll make sure Frank's proud of me.' He was bursting to show everyone what he was made of!

The Flowerbomb exploded, but there was no bang. There was no sound at all. A big, bright rainbow appeared in the sky. What a beautiful display! Then the rainbow burst apart and thousands of flowers came swirling and twirling down to the ground. What a wonderful smell! The speechless ministers stood watching – and they weren't the only ones. Everyone, all around, was looking up into the sky in amazement.

'Ooooh! Aaaah!' they cried. 'How beautiful! So gorgeous!' They were all so excited about what they'd just seen. And they sighed as they remembered how magnificent their land had once been, when you could always see such beautiful flowers around you, everywhere you looked.

Even the president fell silent for a moment. 'Hmm,' he thought, 'this could actually work to my advantage. After all, my popularity could do with a bit of a boost.' And he got straight on the phone to the bomb factory and asked to speak to Mr Cash. In spite of his high temperature, Mr Cash struggled out of bed to get to the phone. No one that important had ever phoned him before.

'I want to order a hundred of those flowerbombs,' said the president. 'I don't care how much it costs.'

'What are you talking about, Mr President?' asked Mr Cash. Mr Cash was only too keen to make some money, but he had no idea what a flowerbomb was.

'You just make what I ordered, Mr Cash. I want one hundred flowerbombs,' the president declared, and then he hung up.

So, anxiously, Mr Cash called Frank.

'Frank!' he yelled into the receiver. 'How do we make flowerbombs? You have to help me. The president just ordered a hundred of them!'

100

Frank smiled, because he knew his plan was working.

'Calm down, Mr Cash, I'll make sure he gets his flowerbombs.'

Frank told all the factory workers to go out picking flowers and for weeks everyone in the factory worked hard to make new flowerbombs. But instead of sending them to the president, Frank sent the flowerbombs to a hundred different places in the land, where people set them off. Rainbows appeared all over the sky and hundreds and thousands of flowers swirled and twirled down to the ground. The whole land smelled of honey.

The people soon realised that the war had to come to an end. They wanted to make the land as beautiful as it once had been, when there were green hills and meadows of flowers everywhere and the ocean was a magnificent shade of deep blue. And they knew what they needed: a new leader. A new president!

Minister Bright immediately understood what had to be done. She ordered the security staff to arrest President Black and they led him off in handcuffs.

'But I ordered all of those flowerbombs! I'm responsible for this wondrous beauty!' he shouted as he was taken away. But no one was listening to him.

The land soon held elections. And guess who the people voted in as the new president! That's right – Frank!

CANDY
FLOSS

There was once a little girl who was very sweet. Her real name was Doris, but everyone at school called her Candy Floss. That was because someone in the playground once said she had frumpy hair. And it was so pink that she looked just like a ... a ... stick of candy floss! Of course, Doris didn't like that name at all, but no matter how much she insisted that her name was Doris, all the other children called her Candy Floss from then on.

After a year, she was so used to it that she could hardly remember her real name. So when her family moved house and she started at another school, the new teacher asked her what her name was and she answered very politely, 'Candy Floss, miss.' The other children fell silent. They were all jealous of her unusual name because their names were so ordinary and plain! And, from then on, sweet Doris went proudly through life as Candy Floss.

THE BUTTERFLY AND THE WIND

t was the height of summer and the butterfly was feeling very happy. She had only just been born, so the world was still very new to her. But she loved everything she'd seen of it so far. There were the most beautiful flowers everywhere, full of delicious nectar, and the sun was lovely and warm as it shone down on her wings. Happily, she fluttered up and down, high and low. And sometimes she sang a little song and her voice was so enchanting that all of the flowers listened to her. She sang very sweetly:

I float and I fly,
flap my wings in the sky,
ride the breeze for hours,
and sing to the flowers.
Ah, my season in the sun,
so much freedom, so much fun.

She had never known any cares or worries, so she was always bright and cheerful.

An exhausted bird, who had just flown a very long way, told the butterfly how lucky she was to be so light, since she didn't need to flap her wings too hard to rise up into the air.

'That's true,' said the butterfly, 'the wind's my friend. But it's your friend too, or you wouldn't be able to fly. Just think about all those poor flowers and animals that always have to stay down on the ground. They can never come as close to the sun as we can with our wings. We're so free!' The bird was very impressed by this clever thought. He thanked the butterfly and flew on happily, enjoying his newly discovered freedom.

The butterfly absolutely adored red roses. She thought they smelled the best of all the flowers. She would often perch on a red rose and have a look around at everything that was going on before fluttering off on her way. She loved how fresh and green the leaves on the trees were. When the wind blew through them they rustled so beautifully. It was like an open-air concert just for the little butterfly.

One day, a small green leaf called out to the butterfly and said that it would love to fly, just like her. 'I can feel the wind,' said the leaf, 'but I'm stuck to this branch. What does it feel like to be able to fly? Can you tell me?'

The butterfly answered that it was wonderful, but told the leaf that it should be pleased that it could play in such a big orchestra and hang so high up in the tree. 'You must have the most beautiful view of absolutely everything from up there.'

The leaf liked that thought and took a good look around at the blue sky and the white clouds and the green fields full of flowers.

110

'THEY CAN NEVER COME
AS CLOSE TO THE SUN AS
WE CAN WITH OUR WINGS.
WE'RE SO FREE!'

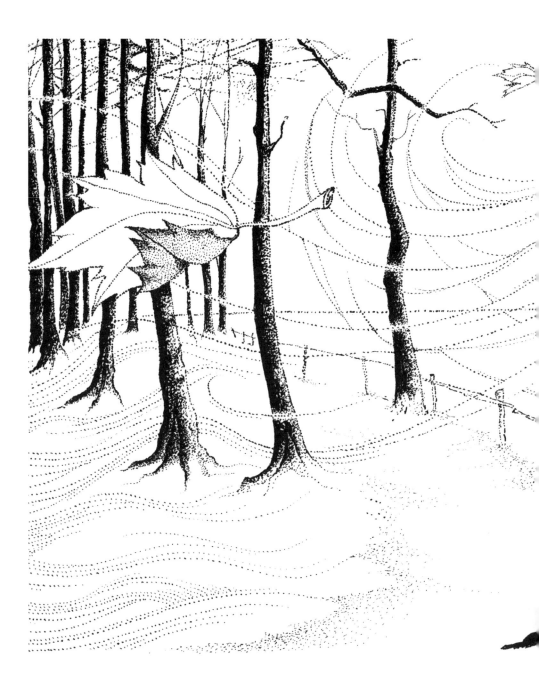

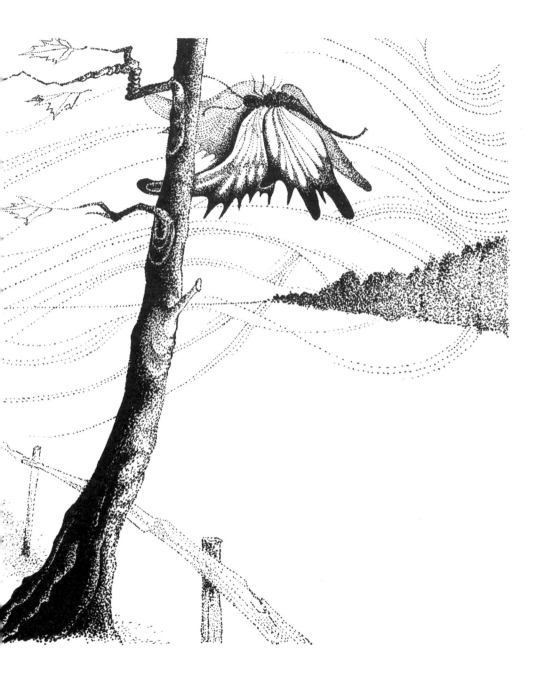

'Goodbye, sweet leaf,' sang the butterfly as she fluttered off.

That summer lasted longer than other summers, but it was the only summer the butterfly had ever known. Even so, it gradually became colder. In the beginning, the butterfly didn't notice and she decided that she just needed to move her wings a little faster to warm herself up. That helped at first, but it also made her very tired. She hoped it would be warmer the next day. But the wind, which had always been so warm and friendly, grew stronger and stronger and sometimes blew her in completely the wrong direction. But she still delighted in everything she saw around her, even though she suspected that the colours that had once been so bright were starting to look just a little dull. The leaves were almost brown, rather than the beautiful green they had been, and the red roses didn't seem quite as red as before.

Sadly for the little butterfly, the days didn't get warmer and the bright colours didn't return. The butterfly, who had sung so beautifully in the summer, developed a sore throat and occasionally she even coughed. The wind was sometimes so strong that she couldn't even fly properly. She fluttered and fluttered, but just stayed in the same place. The clouds became so big and grey that they now covered the sun completely. The butterfly wasn't the only one who could tell that summer was over – the flowers could feel it too.

'Butterfly,' called the roses, 'sing again so beautifully, the way you used to. We're so chilly and maybe your song will warm us up a little.' The roses had made the butterfly so happy in the summer sun, when she had sat on their petals and enjoyed their scent. She was only too pleased to return the favour. So she sang in her hoarse little voice:

114

'SING AGAIN
SO BEAUTIFULLY,
THE WAY YOU
USED TO.'

I float and I fly,
blow high into the sky,
cold wind carries me along,
but chills my happy song.
Where's my season in the sun?
Where's my freedom and my fun?

The roses thanked the butterfly, even though her song only made them feel colder.

The wind grew stronger and stronger and sometimes it was so strong that the butterfly couldn't even see anything. She felt as though there was no strength left in her wings. And when yet another gust of wind blasted through the trees, the butterfly just closed her eyes, gave in and let the wind take her. She thought about the sun, but felt the violence of the storm. She could feel herself falling, but she had no strength to fly. When she opened her eyes, she spotted the leaf that had once been so green, now hanging limp and brown on its branch. She fell towards it and the two of them tumbled away together.

'Oh, thank you, butterfly,' the leaf said. 'You knocked me from my branch and now I can fly too.'

'But I didn't do anything,' the butterfly said. 'It was the wind that blew you from the branch.'

'Flying is so wonderful. You were so lucky to be a butterfly and to fly with the wind.'

This thought made the butterfly happy and she remembered the beautiful summer and how joyful she'd been. She fell and fell and the leaf said, 'You look like a leaf, just like me.'

And the butterfly replied, 'And you're flying just like a butterfly.'

A gust of wind blew them back up again one more time, towards the sun. The sun peeped briefly through the

clouds and, as they fell again, the butterfly sang happily
with her last sigh:

> *I fall and I fly,*
> *even as I die.*
> *I'm happy to say*
> *I loved every day*
> *of my season in the sun.*
> *And now my song is done.*

And the voice of the butterfly vanished in the whistling
of the wind.

THE
FIFTH
PERFUME
BOTTLE

n Princess Shanilla's dressing table there were five small perfume bottles. Each bottle contained a different scent, and Shanilla sprinkled herself every day with a few drops from one of the bottles. The princess loved to smell nice. She hummed a little tune to herself as she skipped through the palace and, everywhere she went, she left behind a little cloud of the most exquisite perfume.

The five scents in the bottles were all different, so the bottles were numbered from one to five. The perfume in bottle one smelled of flowers, like roses and violets. Bottle two contained an unusual and special perfume made of spices from faraway lands. Bottle three was full of the fragrance of fresh fruit. One day it would smell a little like melons and the next day it would smell of ripe cherries. Bottle number four gave off a very rich and

relaxing scent, a lot like incense. And bottle number five contained Princess Shanilla's favourite smell: vanilla. The scent reminded her of cake and of summer.

The five bottles absolutely detested one another and every day, whichever scent Shanilla chose, the other four were insanely jealous of it. 'Choose me, choose me!' the bottles cried, but of course Shanilla couldn't hear them and she could only choose one of them anyway. Shanilla liked the vanilla scent best of all, so she used as little of it as possible. She wanted to save her vanilla perfume for very special occasions, like birthdays and visits to the fair.

But of course the bottles didn't know that. Bottles aren't mind readers, after all. So bottle number five was sad, because Shanilla hardly ever used him and he was still so full of perfume. He even thought Shanilla didn't love him. The other four bottles thought the same, so they looked down on bottle number five and did everything they could to make life miserable for him.

'Vanilla's so common. Roses are far superior,' said haughty bottle one with her floral scent.

'Shanilla thinks we smell so much better than you. Who'd want to smell like vanilla? No wonder she never picks you, biscuit breath!' giggled the other three bottles.

Bottle number five actually thought he smelled very fine, but he was starting to wonder. Maybe he didn't smell that great. And when Shanilla did open the bottle of vanilla scent – for example, on the birthday of her father, the king – the other bottles all laughed out loud and one of them would say something like, 'Shanilla just feels sorry for you, Vanilla. Why else would she open such a pongy bottle?' And they all tinkled with glee as they made fun of poor bottle number five.

Bottle five, who had always been so pleased whenever the princess chose to wear him, started to think

'CHOOSE ME,
CHOOSE ME!'
THE BOTTLES
CRIED.

that maybe the other bottles were right. And that made him sad.

Shanilla used the other bottles so often that, as time went by, there was very little scent left in them. And one day, bottle number two was suddenly ... empty! To the horror of the other bottles, Shanilla just threw bottle two straight into the bin, quick as you like. The other bottles gasped.

'My heavens,' cried bottle number one. 'When our scent has gone, we're going to end up in the bin too, without so much as a goodbye.' The beautiful perfume bottles couldn't imagine anything more unpleasant.

And from that day on, their attitude changed. Now they were scared that Shanilla might use them up. 'Don't choose me, don't choose me!' they begged, day after day. But of course Shanilla didn't know what the bottles were saying. And it wasn't long before the princess finished bottle three and threw it in the bin. The remaining bottles, numbers one and four, were so jealous of number five now, because he was still almost full.

'You must be so happy,' they sighed at number five. 'You're going to stay on the dressing table longest of all.'

But bottle five just felt sad. 'What do I care?' he said. 'I'd rather end up in the bin than have Princess Shanilla think I smell bad. I really love the princess and all I want in this world is to make her smell good.'

Before long, bottles one and four were finished too and Shanilla threw them both away at the same time.

'Bye, bottle number five,' they called. 'Sorry we were so mean to you!'

Now bottle number five was the only one left on the dressing table and he felt really ashamed. 'If Shanilla uses me now, it's only because she doesn't have any other choice.' If he could have, he'd have jumped into the bin

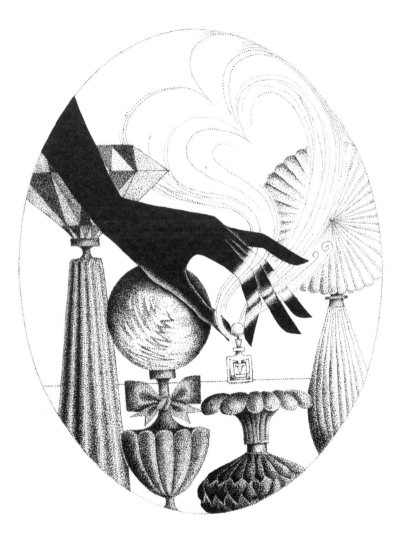

after the other bottles. He knew that he stank, so the best place for him was in the bin, with all the other stinking rubbish. And if the other bottles were still there, at least he wouldn't be all alone. But bottles can't walk, so he had no choice but to stay there on the dressing table.

Of course, Princess Shanilla was really happy that she only had the vanilla scent left now and she decided to use the rest of the perfume on the most wonderful day of the year: the midsummer festival.

On the evening of the festival, the princess put on her most beautiful lace dress. She wove flowers into her plaits and looked absolutely stunning, with the white lace glowing against her dark skin.

Then she sat down at her dressing table, listening to the sound of the crickets outside, and for the first time she spoke out loud to bottle five.

'I think vanilla is the most delicious scent ever and I'm so happy that I've saved so much of you for this special evening.'

Bottle five was so happy that he almost cried. Finally he understood why Shanilla had used him so rarely. He shivered with joy as Shanilla dabbed him onto her neck and splashed him onto her wrists. When he was empty, he expected her to throw him into the bin and he braced himself for impact. But the princess put the bottle back on her dressing table and left the room.

'She'll throw me away tomorrow, then,' thought the bottle. 'But I don't mind, because I've never been so happy.'

The next day, Shanilla walked over to the dressing table with a huge smile on her face. She picked up the bottle, but instead of throwing it away, she held it to her heart.

'Thank you, bottle,' she whispered. 'Tonight I met the love of my life, and it was all because of your beautiful vanilla scent. The prince said he'd never smelled anything so delicious. And so that I never forget last night, I want to keep you with me for ever and ever.'

The prince loved his princess very, very much and so he made sure that the princess's wish came true. He had the very best goldsmith in the kingdom come to the palace to make a beautiful gold chain for the scent bottle. And so it happened that bottle number five came to hang forever close to the heart of Princess Shanilla.

THE
SNAIL

oooh, I moooove soooo slooowly,' thought the snail. She'd been plodding away all morning, but still she'd moved only a few centimetres. She'd been staring at the same autumn leaf all that time, but she just couldn't seem to get past it.

'Dash it!' she mumbled to herself. 'I know this spot like the back of my shell. I wonder what it's like behind that tree over there ... The grass looks so much greener and I bet it's really beautiful. Ooooh, if only I could move just a little more quickly!'

Hours later, after a lot of grumbling and hard work, the snail finally reached the tree. 'Aha,' she thought, 'now my life is going to change, because I've worked so hard to get here.' But the grass wasn't greener at all and there were other autumn leaves in her way.

'I might as well have stayed where I was. Dash it all! Double dash it all!' the snail shouted out loud.

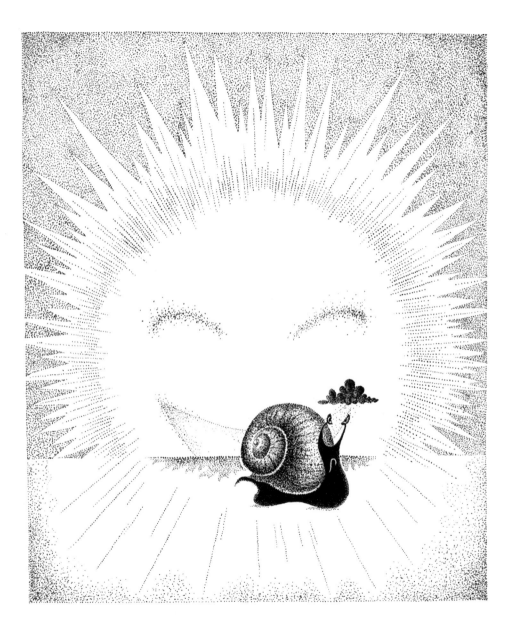

Then she heard a voice nearby. 'Why don't you climb up me, angry little snail?' She looked up and saw that it was the tree who was talking to her.

'Why don't you try going up instead of forwards?' suggested the tree. 'That's the advantage of being a snail. You can stick to anything you like, including me!'

The snail looked up and felt rather dizzy at the thought of climbing all the way up there. But it certainly made a change from going forwards, so she decided to go for it.

She spent the entire climb muttering and cursing the tree. 'Dash, double dash and treble dash!' she said and once she even said, 'Poo and parsley!' The tree just chuckled and quietly let the snail continue on her way. With a lot of dedication, and even more hard work, she reached the top of the tree in just a couple of days.

'Well, now I'm right at the top,' said the snail. 'But what now? I'm just going to have to go all the way back down again, aren't I? Is there no end to my suffering?'

'Just turn around, angry little snail,' said the tree. The snail slowly, slowly turned around and looked down. She saw the whole forest and all the grass and leaves spread out in front of her.

'Ooooh, how beautiful,' she sighed. 'How amazingly amazing! All that time I was crawling around down there and I couldn't see how beautiful it was.'

The tree smiled happily.

'Thank you, Tree!' said the snail.

'So, no more complaining, hey?' the tree said in his strict voice.

'I'll do my best,' replied the snail. 'But dash it all, I've got to go all the way back down again! And that's bound to take a week. Oh, poo and parsley!'

THE
ONE-DAY
WONDER

Dear Diary,
I was born today! It's my birthday! Hoorah! I love it here
already. I'm all cosy and safe and warm. I've got a huge
family and everything's really busy. Mum's chatting away
and telling us all about the world outside. It sounds so
exciting!

Seems that I'm just a very small creature in a big, big
world. We have to keep a careful eye out for big people
who don't want us around. Mum says they're primitive
beasts and we should feel sorry for them. They can't even
fly! Mum's going to clean my wings now and we're going
out for flying lessons. Sounds like fun. I'll tell you all about
it when I get back.

Dear Diary,
Something awful's happened: Mum's dead! Everyone's
terribly sad. I just found out that our kind of fly doesn't live
very long at all. It seems that I'm a one-day wonder.
But what am I going to do without Mum? I can't even fly
yet.

Oh no, someone says we've got to go outside ...

Dear Diary,
Whoooo! Flying's so much fun! I was scared at first,
because Mum wasn't there to teach me, but it just sort
of happened by itself. It's really hot out. To be honest, it's
a bit dull here. There's just lots of stones and sand and
not much to eat or drink. So we've found a donkey and
a couple of people to swarm around for a while. They're
moving sooo slowly. Mum was right about them being
primitive. Oh, what am I going to do now?

Dear Diary,
Everyone thinks I'm a rather peculiar fly. No one else

'ACTION!
FINALLY,
SOMETHING'S
HAPPENING!'

seems to be thinking about how to make the best use of our time. The rest of the family just flew off and left me behind. I don't really miss them though. The donkey's much more fun. He makes funny noises and he keeps stopping to poo. Oh, I love poo. It's so yummy!!! I think it's my favourite thing! And now I'm all alone I have plenty of time to write in my diary. That really is the best fun. It'd be so fantastic if someone in the future could read all about my life.

Hmmm, well, I suppose it might be a bit dull, but what can you expect in these dusty surroundings? Got to look on the bright side though. I'm sure something exciting will happen soon enough ...

Dear Diary,
The two people with the donkey are called Mary and Joseph. But they keep calling each other 'dear' and 'sweetheart', which was a bit confusing for a while. Mary does a lot of complaining. She says she's tired all the time. But I don't know why – she doesn't even have to fly. She just sits there on the donkey! Mary doesn't like it when I sit on her, so I try to leave her in peace. All I can see, wherever I look, is the sun and the desert. I miss Mum.

Dear Diary,
Action! Finally, something's happening! Mary and Joseph want to find somewhere to stay, but it's not easy because everywhere's full and there's no room for them ... Maybe that's because Mary's tummy is so big. So, anyway, we've ended up in this fantastic stable with all kinds of animals (so much poo!) and lots of straw so that Mary can make herself comfortable. I like it here. I already feel at home. I might just stay here for the rest of my life. To be honest, though, I think Mary's a bit of a misery-guts. All she does

is moan and groan. I buzz around, all happily, but she just keeps on giving me these angry looks. That's not very friendly, is it? Oh, it's getting dark outside. Dark! How exciting!

Dear Diary,
Mary's making such a fuss. What on earth is the matter with her? Joseph's so calm. I'm telling you, a woman like that would have driven me insane ages ago. But there's something nice about spending time with the two of them. It's comfortable somehow. And it helps to take my mind off things.

That light in the sky is really irritating. It's shining right into the stable. Mary's complaining about it too. She says it's a real pain. I just went for a fly over there to see what's going on, but there's not much to see. Joseph's hung up a sheet around Mary and Mary's just lying there in the dark.

Whee! Flying's fun, but it's pretty tiring. Need a rest now. Be back later!

Dear Diary,
Mary's had a baby! I feel a bit embarrassed now, because of everything I said about her. It's quite a sight, you know, a birth. Particularly when you're flying by and looking down from above with a fly's-eye view (although Mary did take a couple of swipes at me). She just told Joseph she wants to call the baby Jesus. He's not so sure. He thinks 'Joseph Junior' has a certain ring to it.

I keep thinking about Mum. She didn't even have time to give me a name ...

Dear Diary,
It's really busy here in the stable now. I don't know why,

but more and more people keep turning up. Three men just arrived with gifts. Everyone wants to take a look at Jesus. What's going on? That didn't happen when I was born!

Dear Diary,
Mary and Joseph are having a nap now. I'm sitting on Jesus. He's the only person who hasn't tried to squash me so far. That makes him my favourite. He's so lovely and warm and soft. Ahhh, this is the life!
 I love you, Jesus ...

Fairy Tales by Viktor & Rolf

First published in English in 2011 by Hardie Grant Books

Hardie Grant Books London
Dudley House, North Suite
34–35 Southampton Street
London WC2E 7HF
www.hardiegrant.co.uk

Hardie Grant Books (Australia)
85 High Street, Prahran, Victoria, Australia 3181
www.hardiegrant.com.au

British Library Cataloguing-in-Publication Data. A catalogue record
for this book is available from the British Library.

ISBN 978-1-74270-178-3

Cover and internal design by Mevis & Van Deursen with Johann Tangyong
English language translation copyright © Laura Watkinson
Publication of this title has been made possible with the support of
 the Dutch Foundation for Literature

Printed and bound in China by 1010 Printing International Ltd
Colour reproduction by MDP

10 9 8 7 6 5 4 3